This

BOOK

bELONgS

to:

(FIRST INITIAL) PERiod (middle NamE) SPacE (Last NAME)

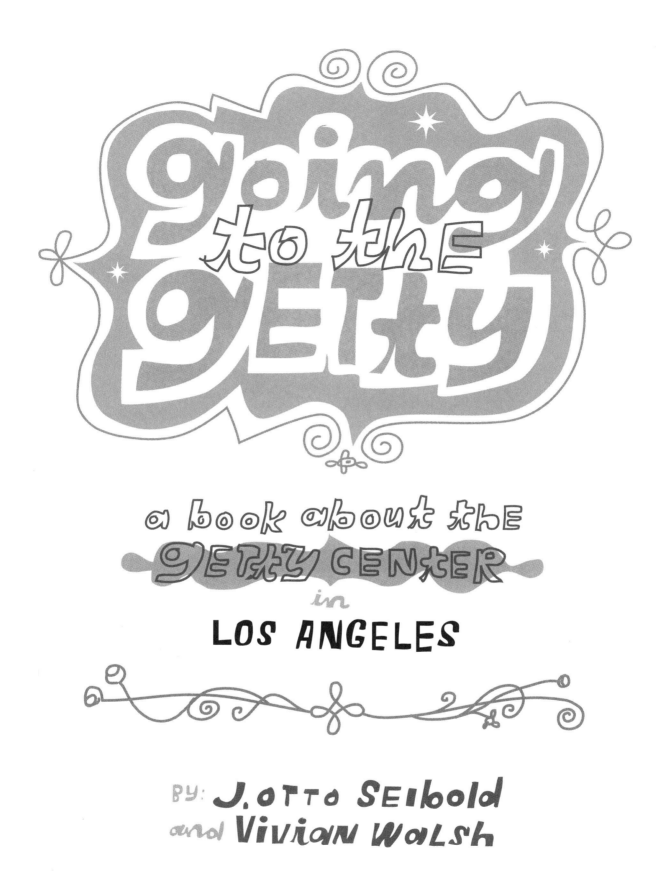

going to the getty

a book about the getty center in LOS ANGELES

BY: J. otto Seibold and Vivian Walsh

The J. Paul getty museum
LOS ANGELES

LOS ANGELES

The Getty Center is in the city of Los Angeles.
Los Angeles is famous for its many freeways
and cars.

There once lived a man named
J. Paul Getty. He sold oil.

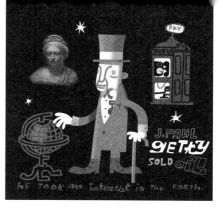

As more and more people got
in cars to drive to places such
as museums, they burned
Getty gas, and Mr. Getty
became very, very rich.
He even figured out how to
make money in his own home:
he had a pay phone installed in his mansion.

He saved enough money to open a museum in his house.
The price of admission was cheaper than a phone call...
it was free.

It is not in his house anymore.
Now his museum has a new home.

It is still free.

The J. Paul Getty Trust is:
a museum
five institutes
a grant program

and a tram.

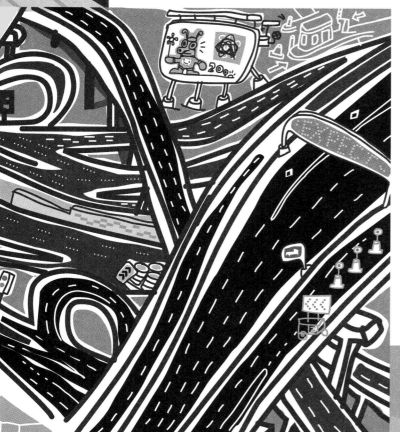

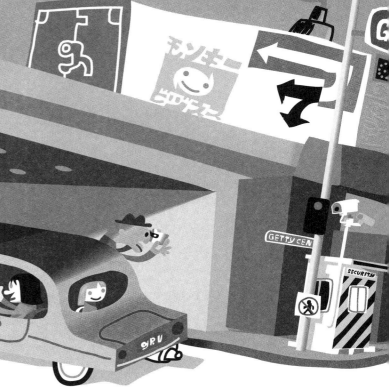

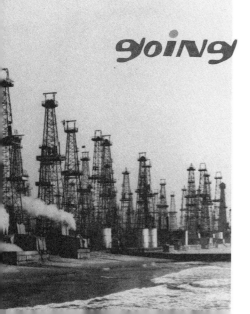

To get to

the Getty

you must

pass under

an

underpass.

You can't

miss it.

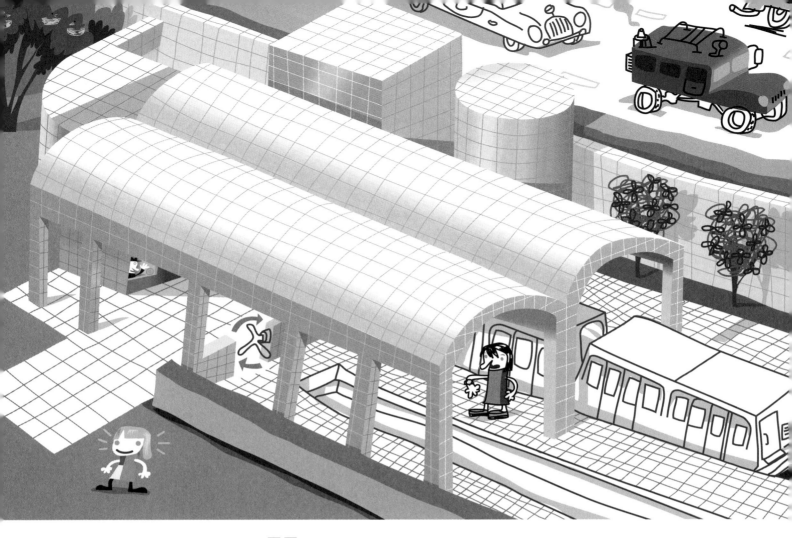

What a lovely **Museum**.

Actually, it is not a museum.
It is a tram station.
A tram station for the rest of the Getty Center.

There is no driver on the tram. It is automatic,
which means no driver.

Where is the driver?

Maybe the driver walked up the hill.

The tram rides on a cushion of air. This system is called HOVAIR.
Blowers lift the tram so it hovers 1/8 of an inch above the track.

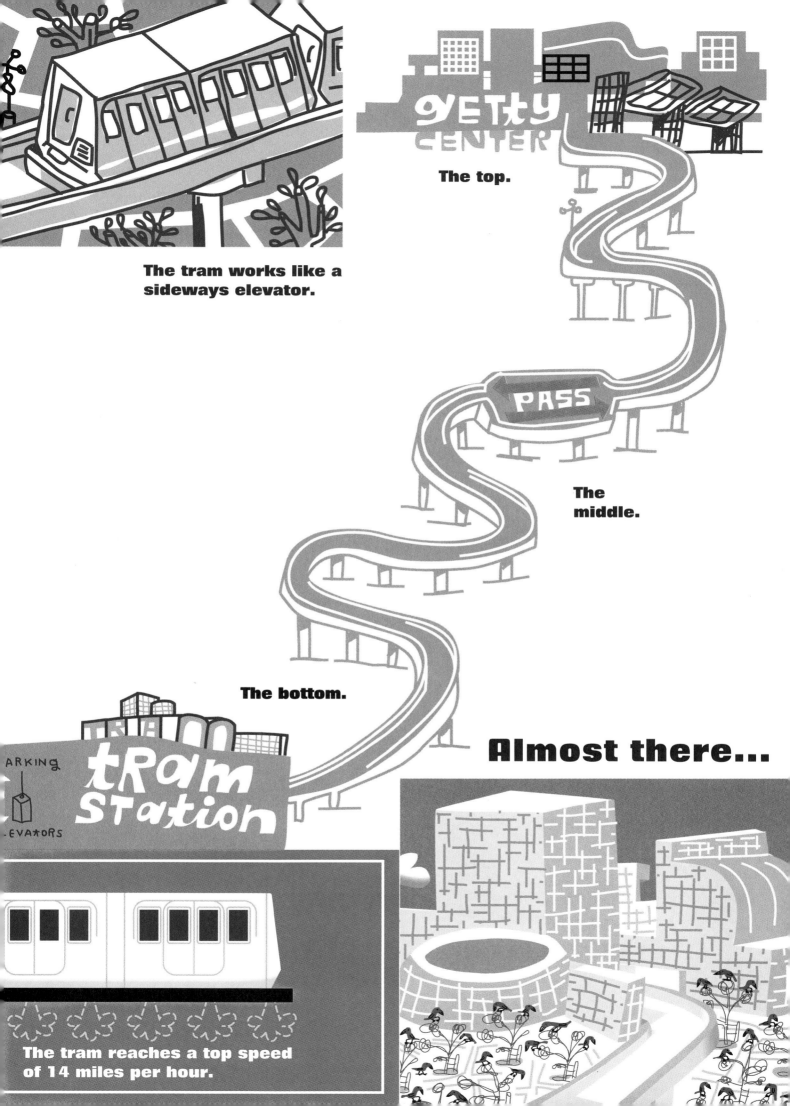

The tram works like a sideways elevator.

gETTY CENTER

The top.

PASS

The middle.

The bottom.

Almost there...

tRAM STATION

ARKING

ELEVATORS

The tram reaches a top speed of 14 miles per hour.

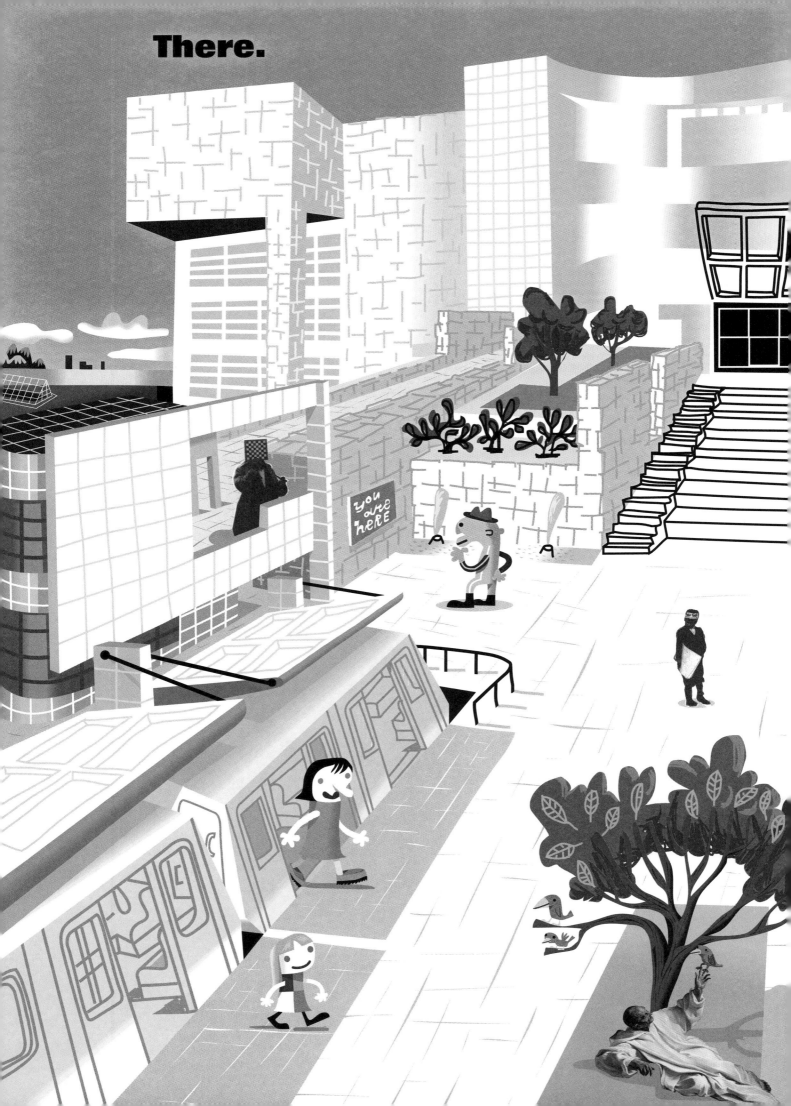

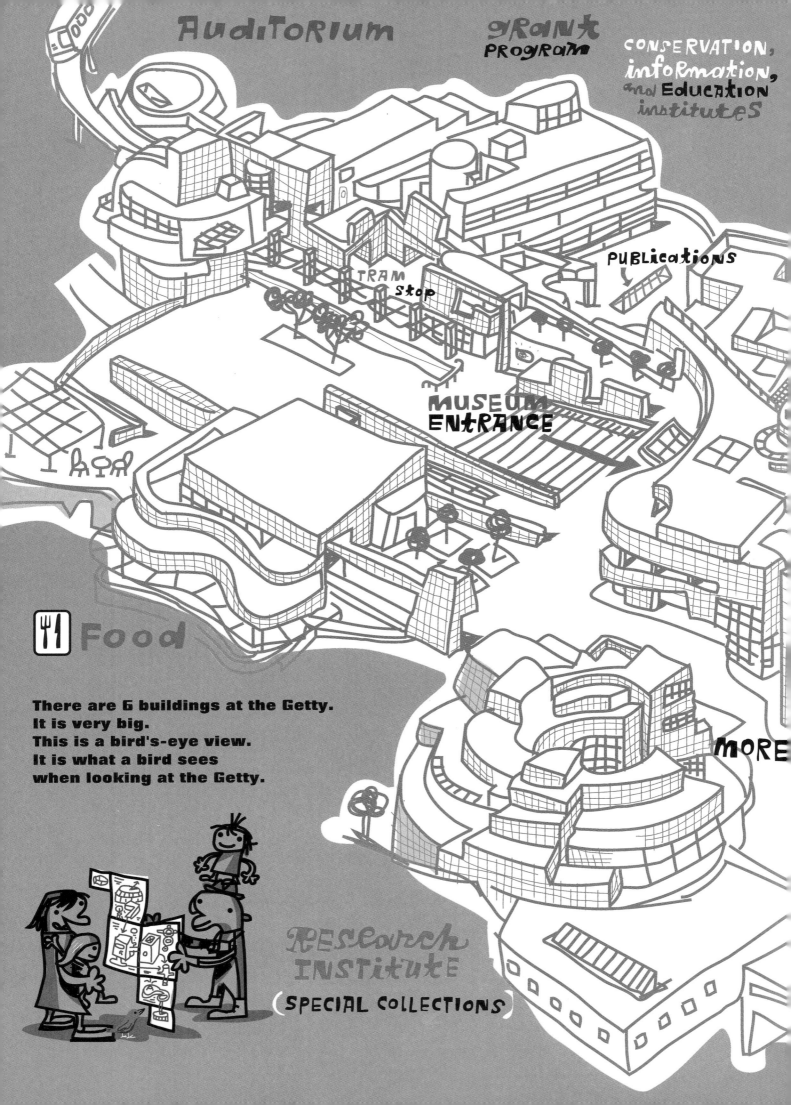

AUDITORIUM

GRANT PROGRAM

CONSERVATION, INFORMATION, and EDUCATION INSTITUTES

PUBLICATIONS

TRAM STOP

MUSEUM ENTRANCE

🍴 **Food**

There are 6 buildings at the Getty.
It is very big.
This is a bird's-eye view.
It is what a bird sees
when looking at the Getty.

MORE

RESEARCH INSTITUTE
(SPECIAL COLLECTIONS)

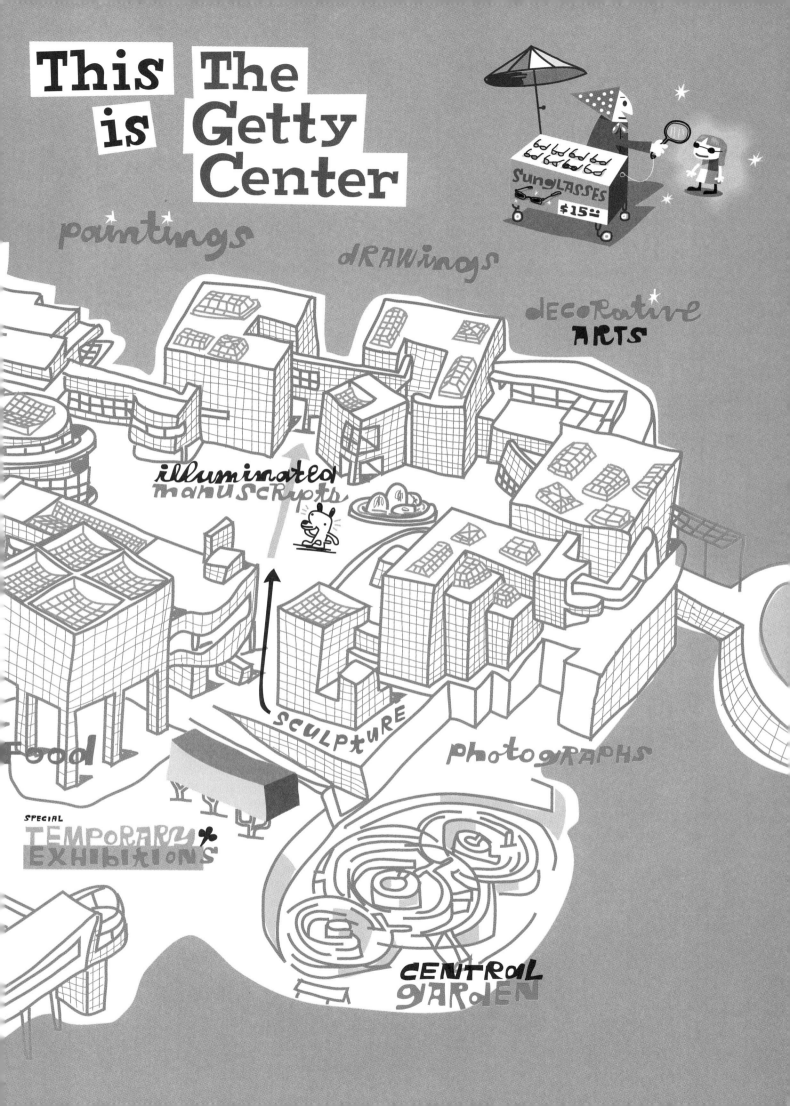

This is The Getty Center

paintings

dRAWings

decoRative ARTS

SUNGLASSES $15⁰⁰

illuminated manuscripts

SCULPTURE

Food

photogRAPHS

SPECIAL TEMPORARY EXHIBitIONS

CENTRAL gARden

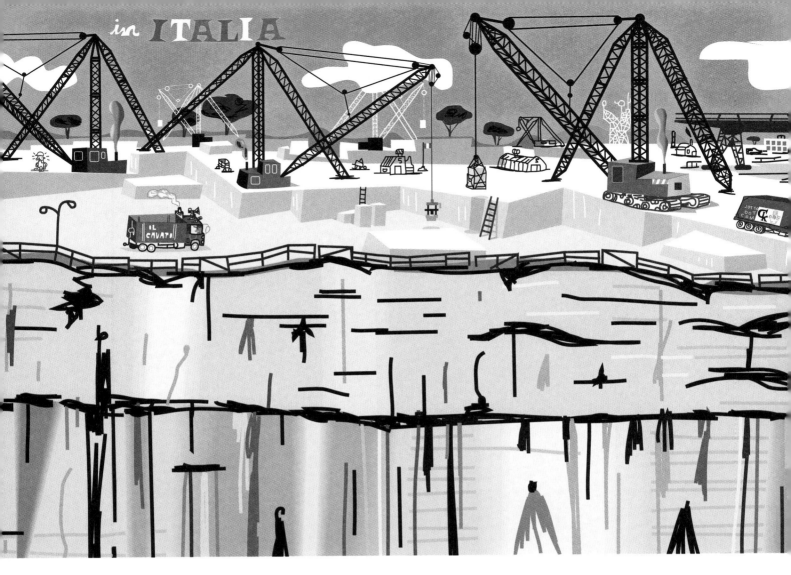

This is a quarry in Italy. Quarries are where rocks come from.
This one has been in operation for 2,000 years.
Now there is a big hole in Italy.
So big, you could fit the hill that the Getty sits on inside of it,
almost.
Where did all the stone go?
It went to the Getty.

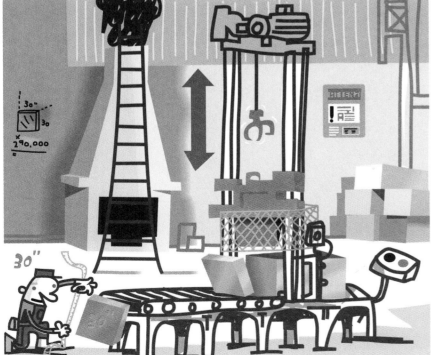

The Getty needed so much stone cut, a new rock-chopping machine was invented.

One piece cut for the Getty had a very old deer antler in it. That one is kept indoors for study. You can see other things in the marble. Like leaves and snails.

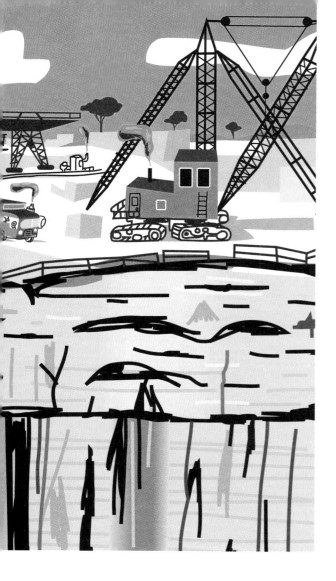

There are
250,000
stone tiles at
the Getty.
A typical tile
weighs 250
pounds and
measures
30 inches by
30 inches.

But not all of
the rocks at the
Getty are
square.
The largest
boulder in the
fountain
weighs roughly
30 tons.

It took over 100 voyages by
ocean freighter to deliver
the marble.

The marble is called
travertine.
It comes from ancient
dried-up lake beds.

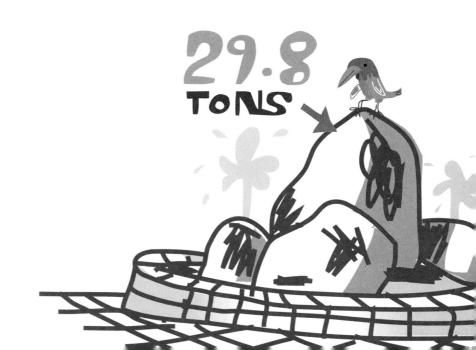

GALLERIES →

paintings

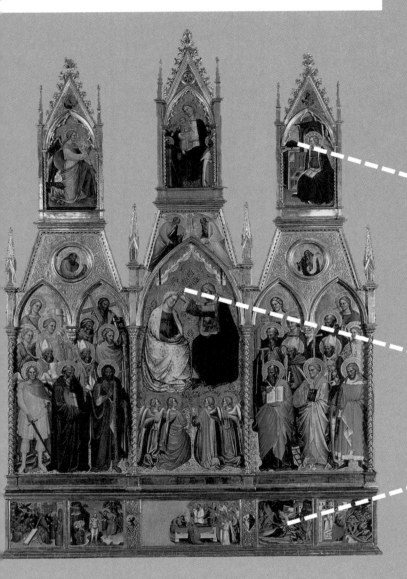

Inside the galleries at the Getty Museum you will find many paintings.
Paintings have been around for as long as paint.
The oldest painting in the Museum is from around 1330, and the newest one is from 1896. So even the newest painting is old.

People see different things in paintings. Sometimes, it just depends on where you are standing.

Paintings often contain stories. There are many clues. Clues can help you figure out the story.

Old Painting Story
A long time ago, life was hard and there were many fights between saints and demons. But then they became friends. **The End**

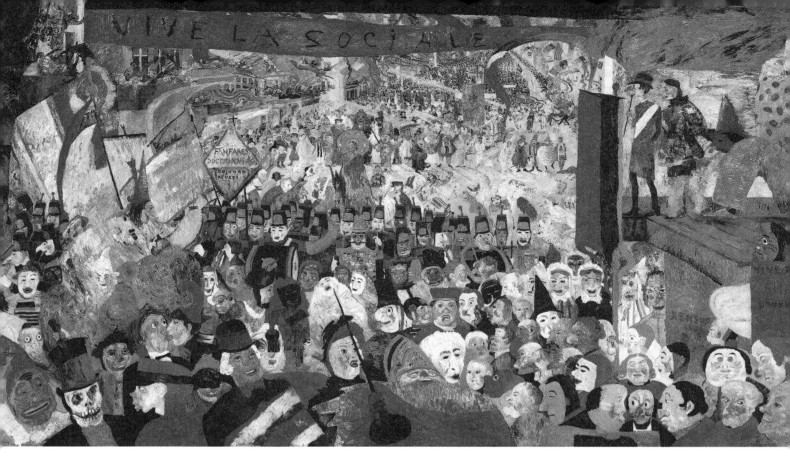

In 1888, the painter James Ensor painted himself in the middle of a big parade.

How would you feel surrounded by these characters?

Hey!

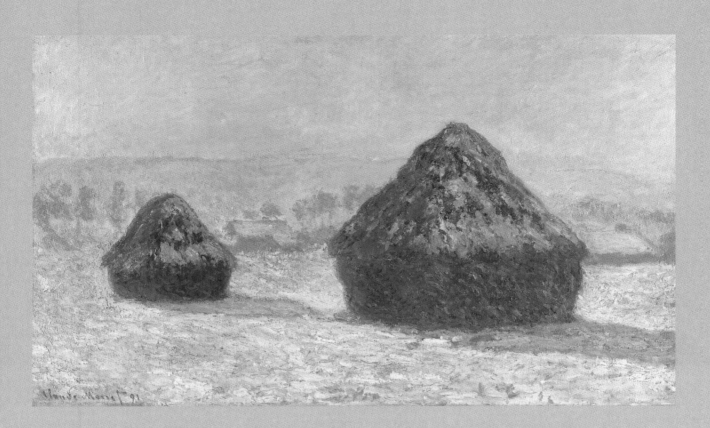

Hay? No, they're wheatstacks!
As seen by C. Monet in 1891.

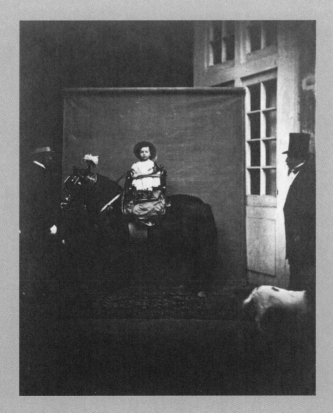

Hay is for ponies,
like the one Pierre-Louis Pierson photographed in
1859, with the Prince of France driving.

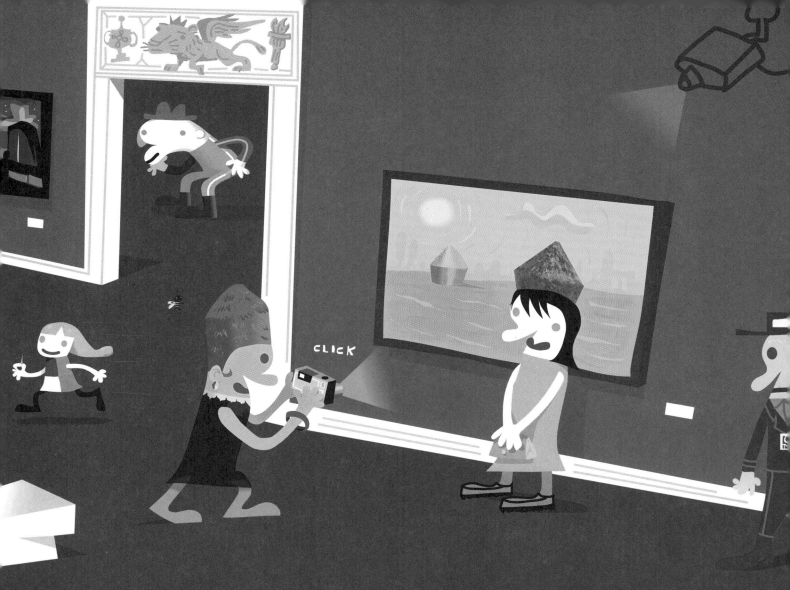

CLICK

COMPOSITION IS EVERYTHING

When making a painting,
or taking a photo,
composition is everything.

It makes something good-looking.

gETTY UP horSEY.

This horse, the Piebald Horse, painted by P. Potter, enjoyed hay in the year 1652.

("Piebald" means "spotted.")

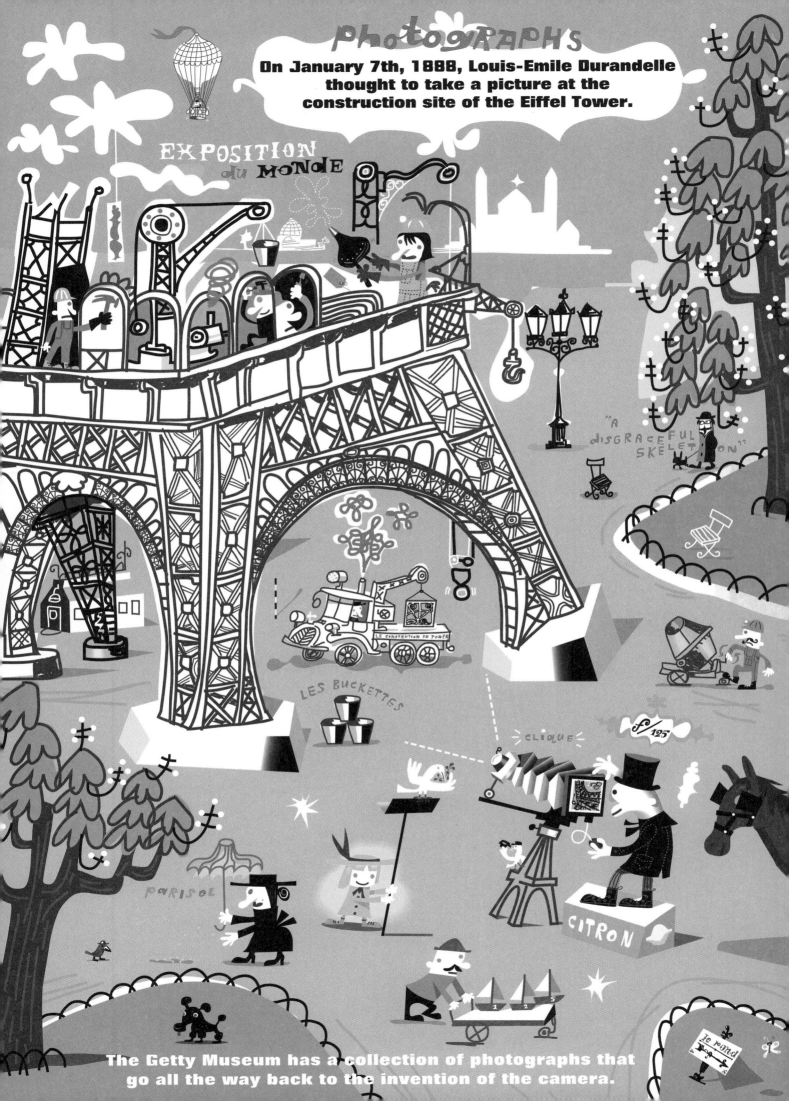

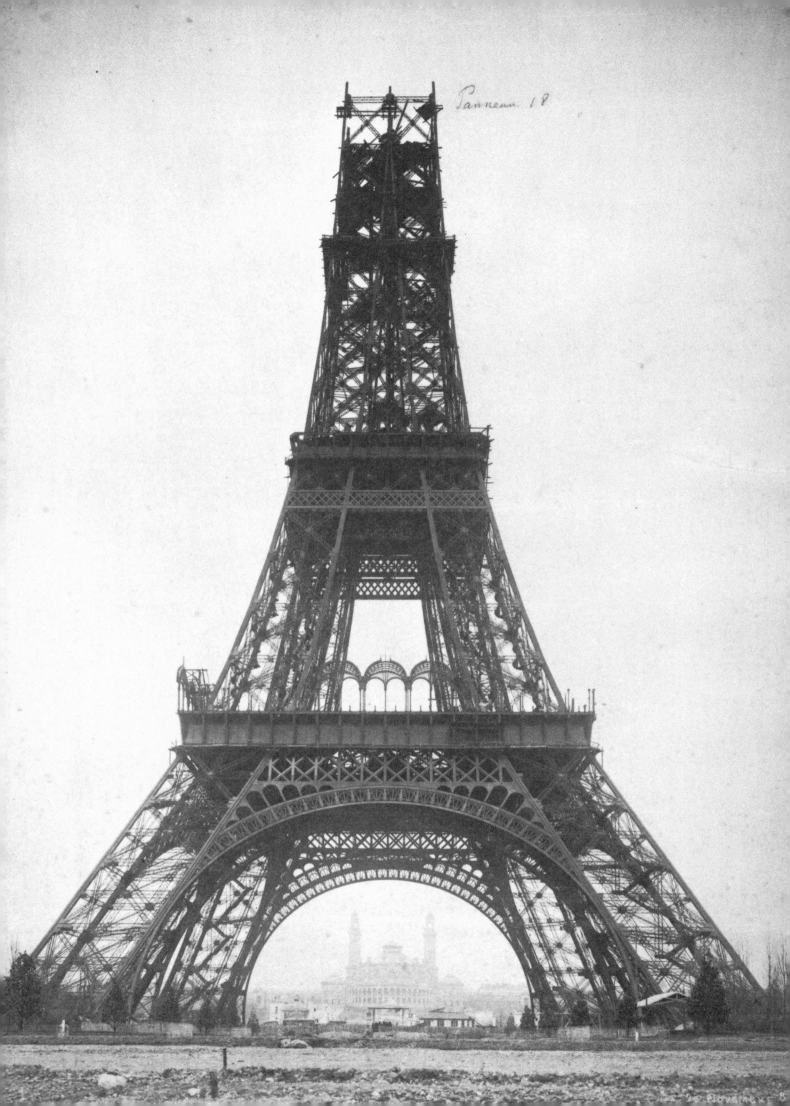

Panneau 18

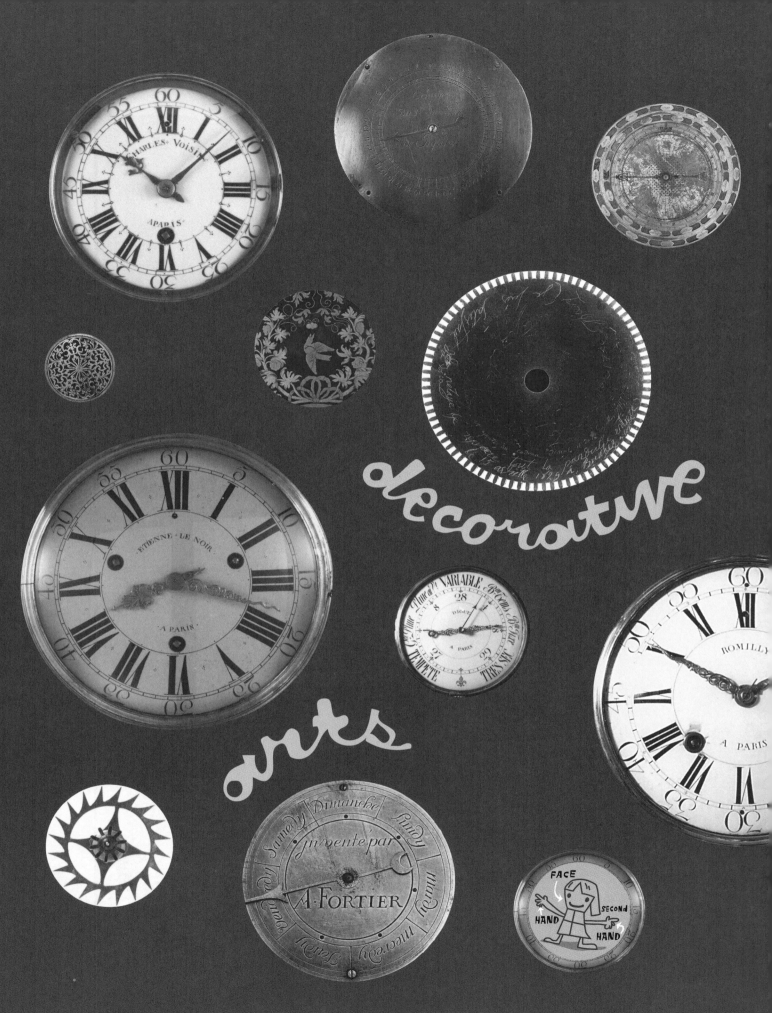

The Museum has 21 clocks:
that's almost one for each hour of the day.
A good amount of hands and faces.

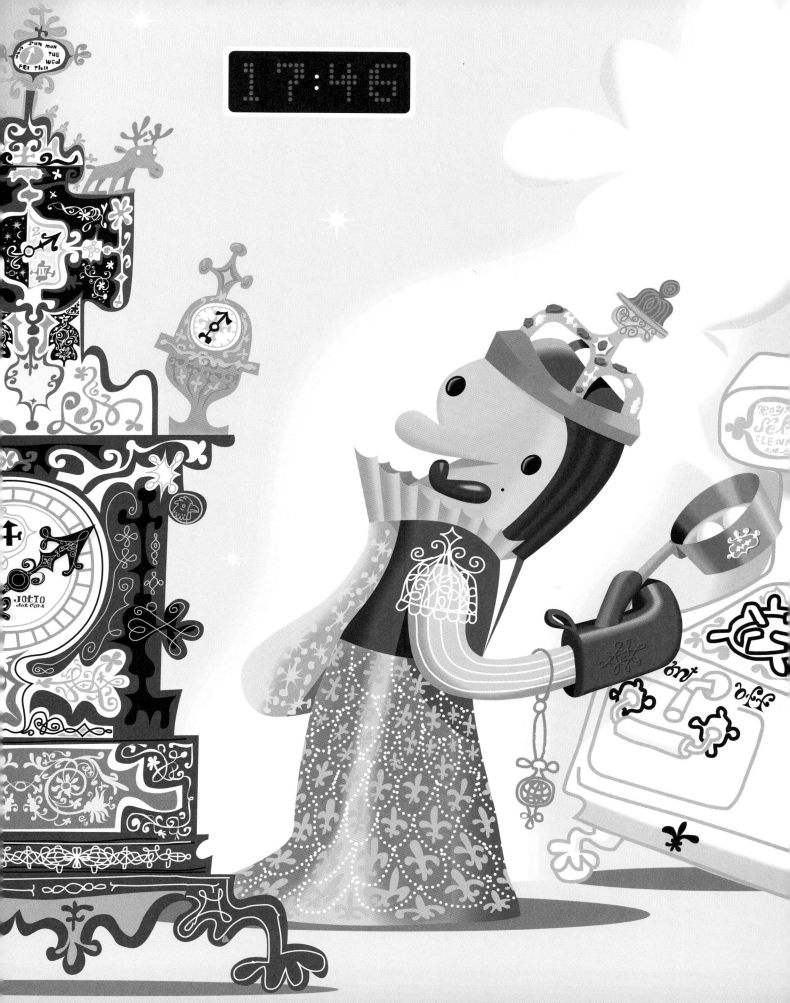

Thanks to the royal egg timer,
the Queen's royal eggs were always perfect.
That was a long time ago.

Drawings and Manuscripts

MANU SCRIPTS

PREPOSTEROUS

How would you draw an elephant if you had never seen one before?

That was the problem for Mr. Anonymous, the artist who made this picture.

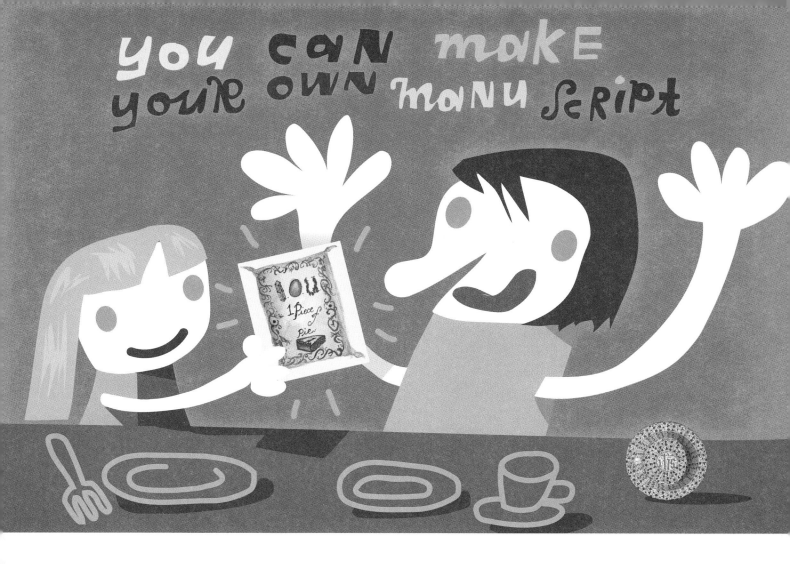

you can make your own manuscript

A long time ago, before computers or printing presses, everything had to be written by hand. Whole books had to be carefully copied, letter by letter. They were manuscripts.

The more important the manuscript, the more it could be decorated with gold, rosebuds, and winged people.

Try the Cézanne Special:

Peaches and a Pitcher.

Later, if you're in the cafeteria and you accidentally eat someone else's pie, try replacing it with a manuscript.

It is called an I.O.U.
And if you want to be taken seriously, make the letters fancy.

That is important when you are dealing in pie.

There's a ramp in the cafeteria that's always moving, ready to take your finished tray away.

It works just like the tram.

Sort of.

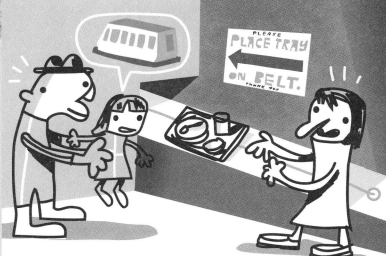

What is SCULPTURE?

The Museum's sculpture department has a large collection of sculptures!

Everyone has an opinion about what sculpture is.

Can you spot the sculpture?

THE STORY OF CONSTANTIN BRANCUSI'S ENDLESS COLUMN

In 1937, the sculptor Constantin Brancusi made a sculpture called *The Endless Column.*

It was erected in the town of Tirgu Jiu, in Romania.

Sometime later a group of city officials decided to tear it down. They thought it was subversive. ("Subversive" means "tricky," sort of.)

They tied one end of a cable to the top of the seventy-foot-tall column and the other end to the city tractor.

But the tower was strong, and the officials were only able to bend it.

The Getty Conservation Institute is helping to straighten things out.

THE CONSERVATION institute

Scientists at the Getty Conservation Institute have saved many ailing artworks. They can tell you what would happen if you spilled a bowl of cereal on a very rare chair.

The Institute has an aging machine. It helps you see how a painting would age if it were left outside for 100 years.

**The people at the Institute also invented a new form of non-intrusive pest control!
That is to say, they are able to rid priceless objects of tiny hungry bugs...without putting tiny holes in the priceless objects.
The whole idea came from advanced potato-chip-bag technology.**

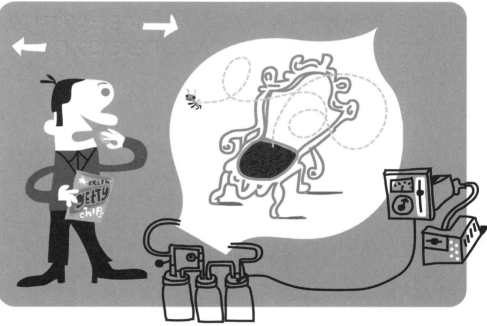

MUSEUM LABORATORIES

Under the Museum, the Getty has more laboratories.

One laboratory is for repairing clocks; another is for fixing photographs.

Still another is just for reassembling things that have been broken for 1,000 years.

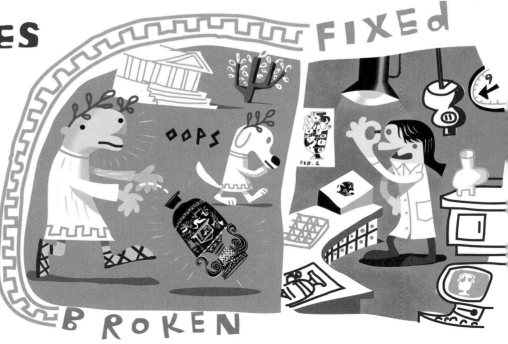

FIXED

OOPS

BROKEN

Dragon's Blood

Bark Husk

Lapis Lazuli

Safflower

Vermilion

King's Yellow

Coal

Iris Green

Mars Red

Sepia

Saffron

Oxblood

Vine Black

Green Earth

Chrome Yellow

Woad

Prussian Blue

Van Dyke Brown

Chinese Blue

Coral

Ultramarine Blue

Naples Yellow

Mold

Mummy

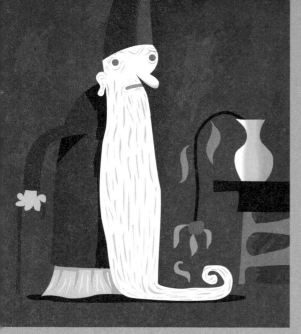

OLD PAINT

Old paintings are covered with old paint. And that is not a problem... until they fall apart.
Then you must repair them.

Sometimes, paintings from other museums visit the Getty for special attention.

If you are fixing an old painting, you should use old paint.
When available.
The Conservation Institute makes its own old paints.
It keeps a collection of them.
They are named just as they were long, long ago.

← LIKE THESE

PLEASE FIX

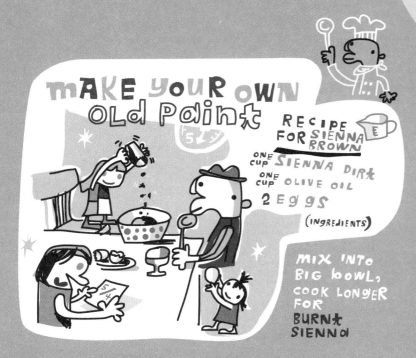

MAKE YOUR OWN
Old Paint

RECIPE FOR SIENNA BROWN

ONE CUP SIENNA DIRT
ONE CUP OLIVE OIL
2 EGGS

(INGREDIENTS)

MIX INTO BIG BOWL, COOK LONGER FOR BURN* SIENNA

Artists would cook up mixtures of wax and something colorful...like berries, or dirt.

A certain ground-up bug made an interesting red.
Burnt vines and sticks were good for black,
bones for white,
and gold for gold.

ROTORELIEF No.3 - LANTERNE CHINOISE - MODELE DEPOSE

The artist Marcel Duchamp made this item for the purpose of spinning.

SPECIAL COLLECTIONS

LES PICK-POCKETS
A
L'EXPOSITION UNIVERSELLE
DE
1889

This book is called LES PICK-POCKETS.

TAD
DUST HOUND
PICK
That Komical Klown

Though he had a happy smile painted on his face, on the inside he was TAD.

Once the Russian artist El Lissitzky scribbled the names and phone numbers of his famous friends in his address book. Now, in the Getty's collection, it is handled with white gloves.

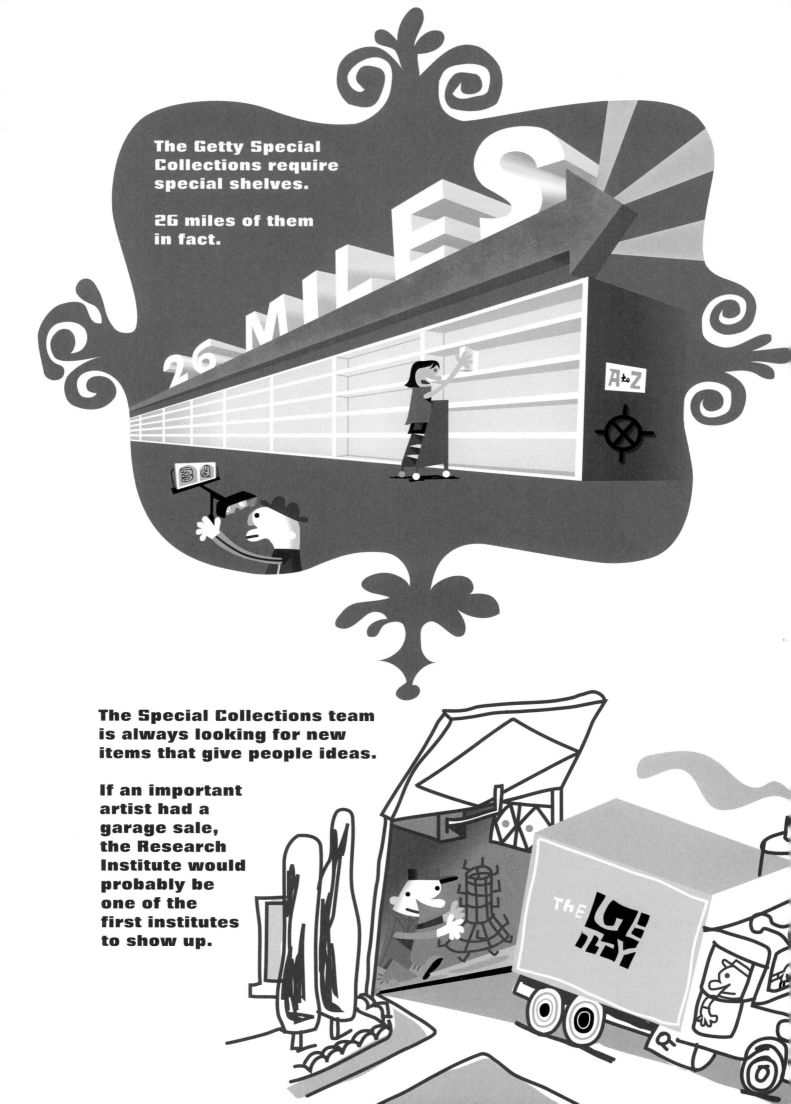

The Getty Special Collections require special shelves.

26 miles of them in fact.

The Special Collections team is always looking for new items that give people ideas.

If an important artist had a garage sale, the Research Institute would probably be one of the first institutes to show up.

CONCEPTUAL GARDEN

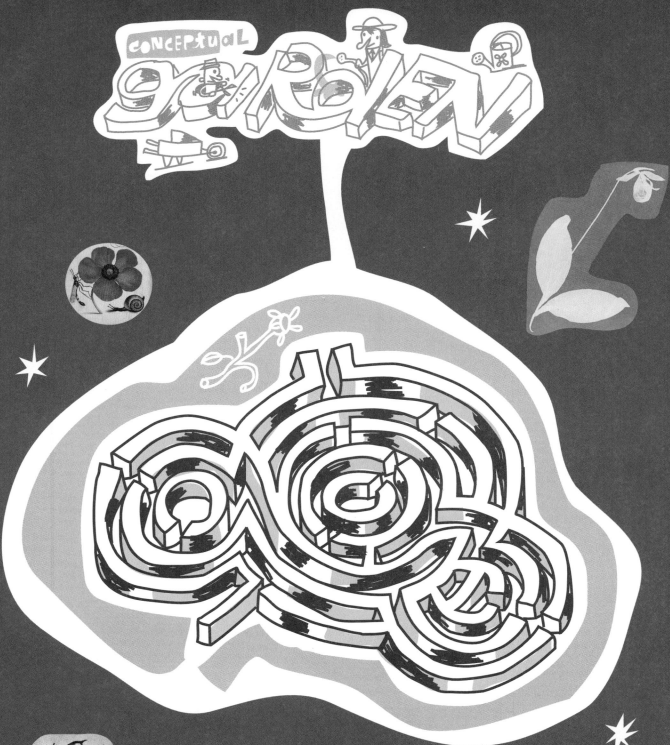

The garden at the Getty was designed by an artist named Robert Irwin.
Usually he makes things that go inside museums...
this one goes beside the Museum.
He made a maze that you can't run around in. That is good, though, because the maze is in the middle of a pond.

The Getty has lots of pictures of bugs and flowers in the Museum. In the garden, you can rest your eyes by looking at the real thing.

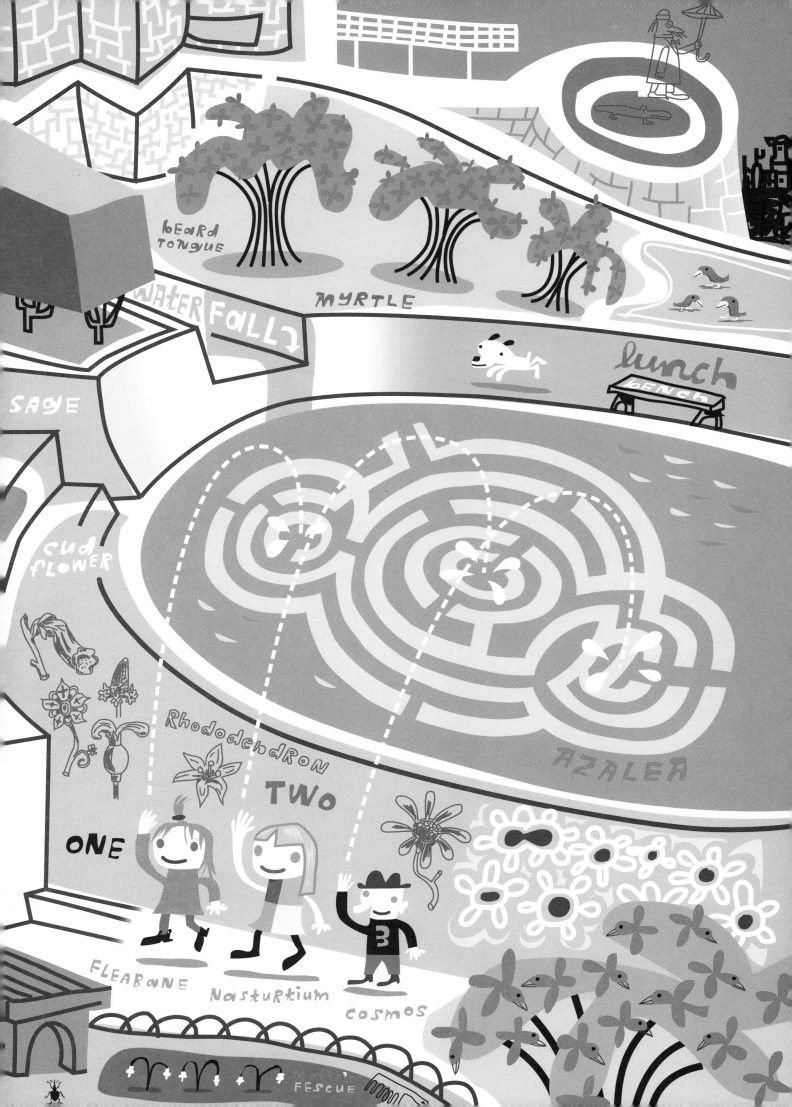

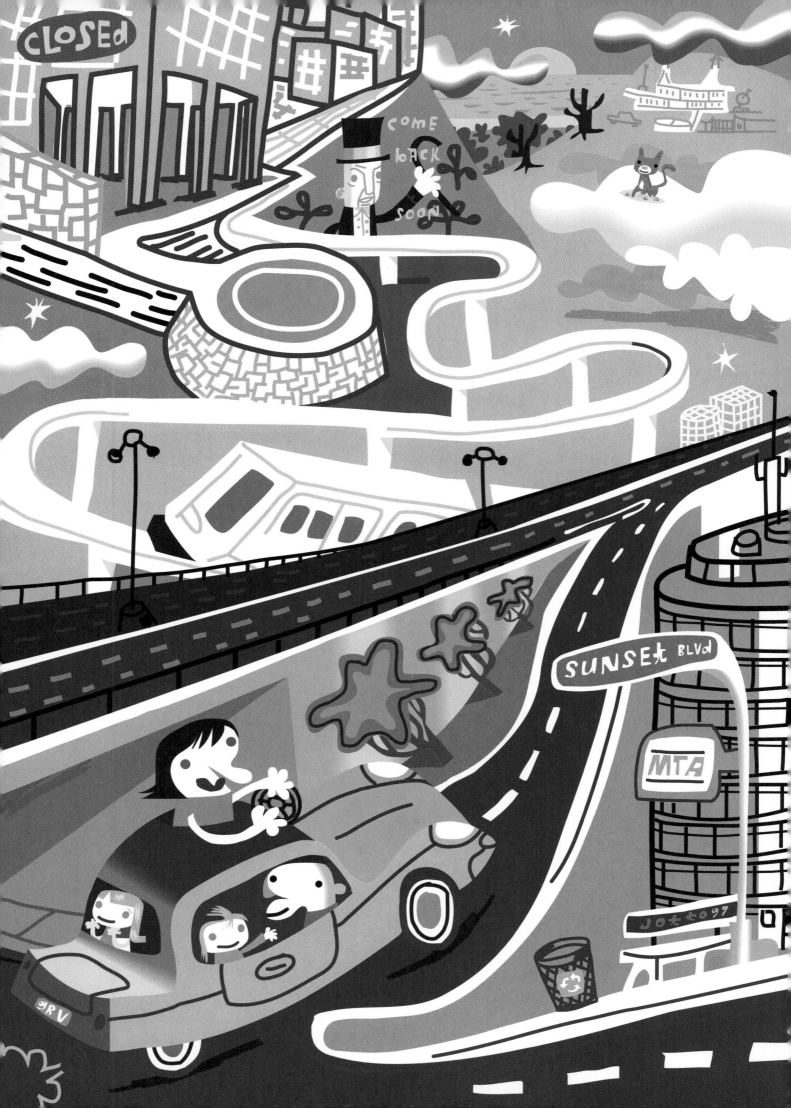

There is still a lot to see
at the Getty Center.
But the fog tells us that
it is time to go home.

We'll save the rest for
the next time we're
going to the Getty.

THE
END.

ONE
dedication
2
NUMBER
THREE
'Ulysses'

© 1997 J.otto Seibold and Vivian Walsh

The J. Paul Getty Museum
1200 Getty Center Drive
Suite 1000
Los Angeles, CA 90049-1687

Second Printing

Christopher Hudson, Publisher
Mark Greenberg, Managing Editor

Deenie Yudell, Design Manager
Karen Schmidt, Production Manager

Project Staff:
J. Carson Harris, Editor (Extra thanks)
Elizabeth Zozom, Production Coordinator

Library of Congress Card Number 97-073127

Special thanks to: John Walsh, Lori Starr, Wim de Wit, Eric Doehne, Sandy Silver, Melena Gergen, Kathy Conley, Jim Mawson, Quincy Houghton, Richard Meier, Hillary Cohen, Bob Walker, Lois Sarkisian, Anna O'Rourke, Corinne Burrell, Moira Walsh, Susan Grode, Regina Hayes, Alexa Burrell, Bud Goldstone, and everyone who showed us around and generally helped us out.

The photograph of oil derricks is courtesy of the Department of Special Collections, University Research Library, UCLA.

To Miroslav Sasek, wherever you are, Thank you.

The Illustrations in this book were created on a Macintosh PowerPC 8500/120 using Adobe Illustrator 6.0 software.
The text is set in Honky Regular. Trudge Gothic and Marcel were used throughout.

OK

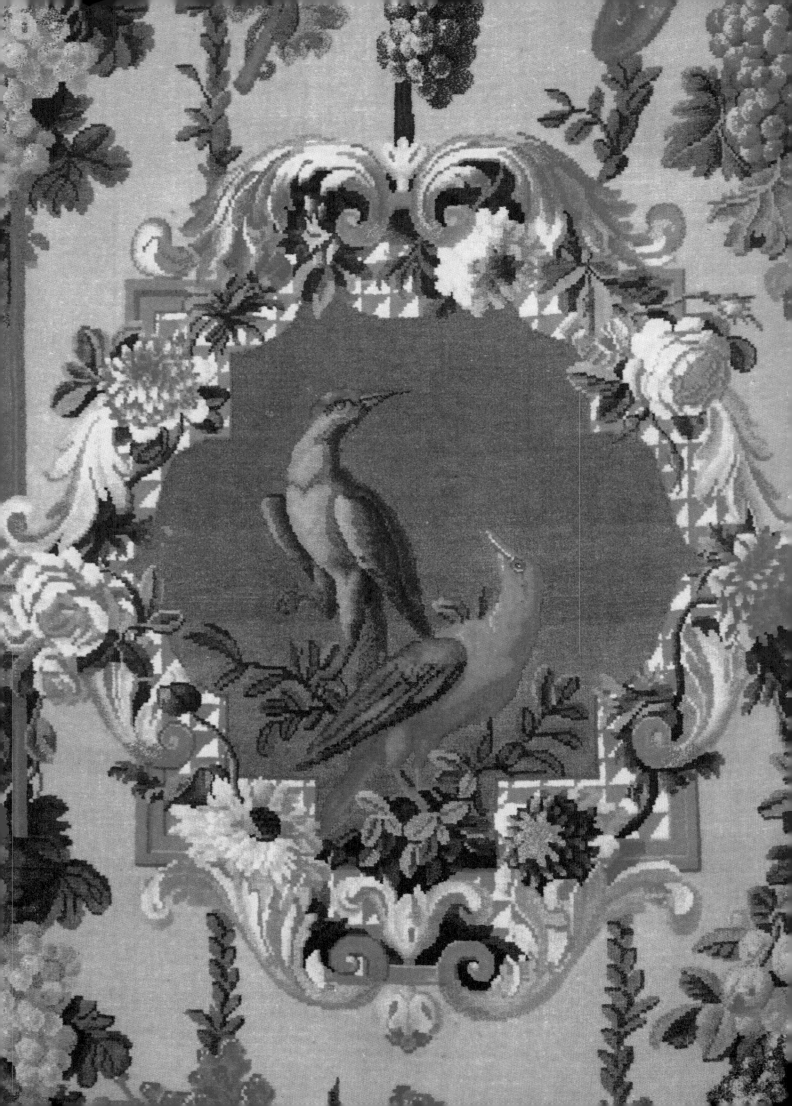